DREAMWORKS CLASSICS PRESENTS

SHREK
& MADAGASCAR

CONTENTS

MADAGASCAR TALES!

16 GAME ON

7 THE DOCTOR IS OUT!

25 COLD FEVER

TITAN COMICS

SENIOR EDITOR **Martin Eden**
ASSISTANT EDITOR **Louisa Owen**
PRODUCTION MANAGER **Obi Onuora**
PRODUCTION SUPERVISORS **Maria James, Jackie Flook**
PRODUCTION ASSISTANT **Peter James**
STUDIO MANAGER **Selina Juneja**
SENIOR SALES MANAGER **Steve Tothill**
MARKETING MANAGER **Ricky Claydon**
PUBLISHING MANAGER **Darryl Tothill**
PUBLISHING DIRECTOR **Chris Teather**
OPERATIONS DIRECTOR **Leigh Baulch**
EXECUTIVE DIRECTOR **Vivian Cheung**
PUBLISHER **Nick Landau**

DreamWorks Classics Volume Three: Game On
ISBN: 9781782762485

10 9 8 7 6 5 4 3 2 1

First printed in Lithuania in August 2016. A CIP catalogue record for this title is
available from the British Library. Titan Comics. TC0554

Special thanks to Andrew James, Steve White and Donna Askem.

SHREK & MADAGASCAR

SHREK STORIES!

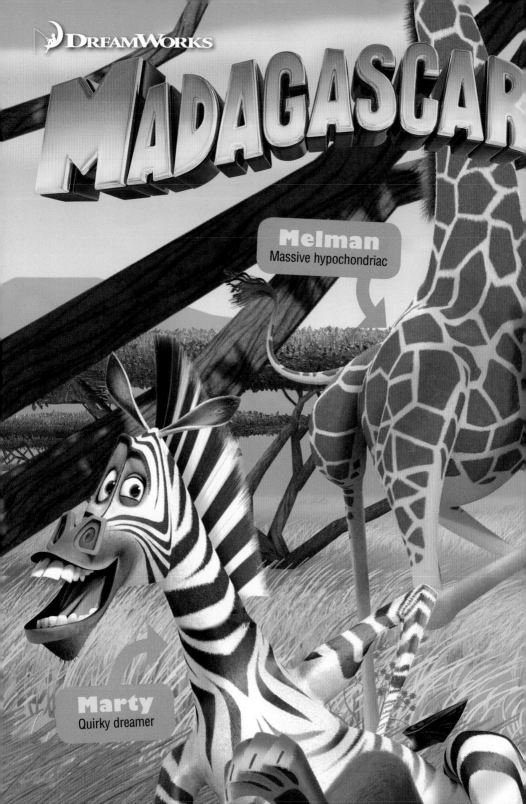

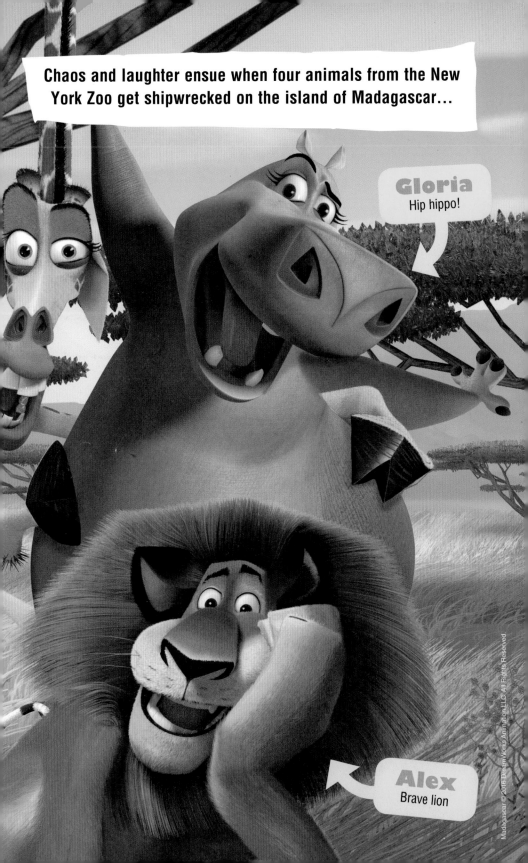

Chaos and laughter ensue when four animals from the New York Zoo get shipwrecked on the island of Madagascar...

THE DOCTOR IS OUT!

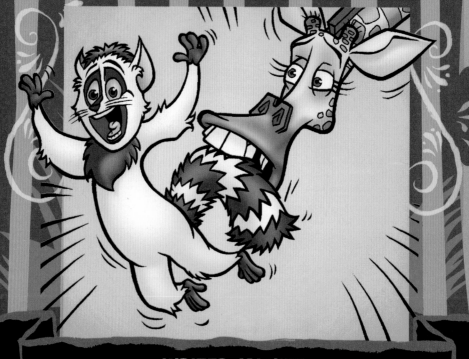

WRITER **JAI NITZ**
PENCILS **RICARDO LEITE**
INKS **BAMBOS GEORGIOU**
COLORS **HI-FI DESIGN**
LETTERS **JIMMY BETANCOURT/COMICRAFT**

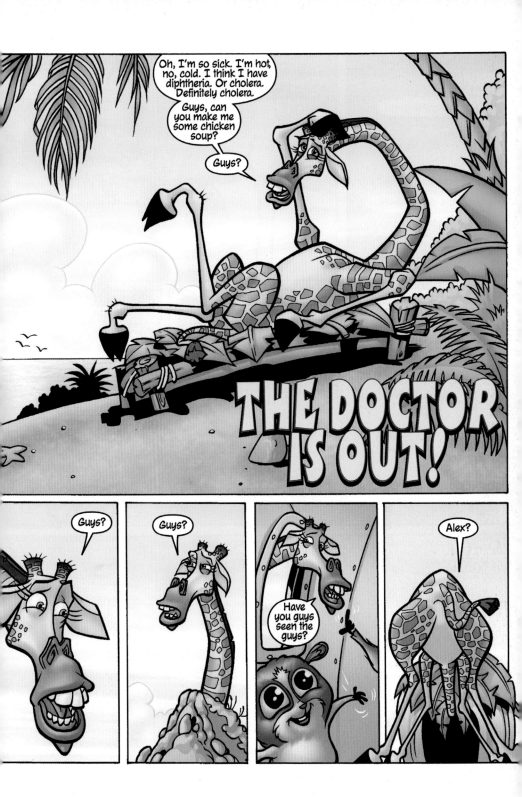

7

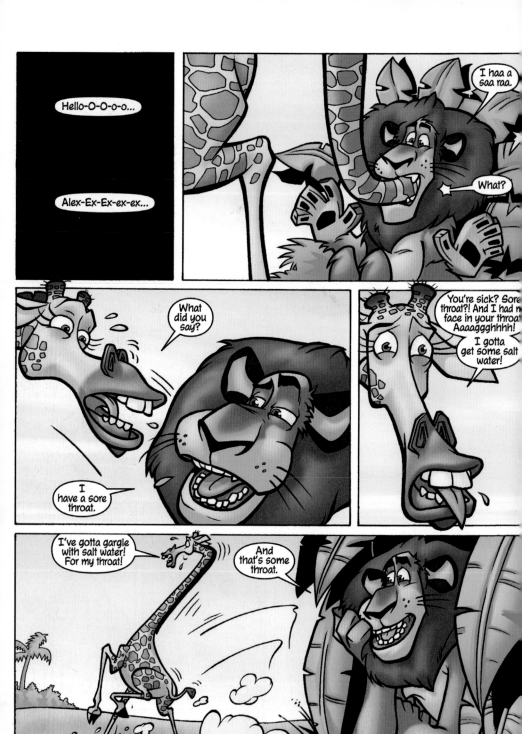

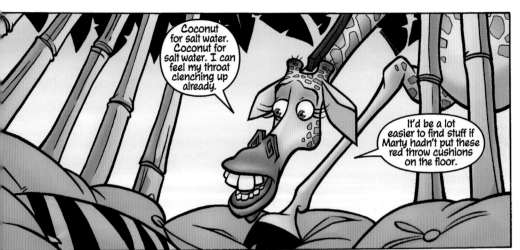

Coconut for salt water. Coconut for salt water. I can feel my throat clenching up already.

It'd be a lot easier to find stuff if Marty hadn't put these red throw cushions on the floor.

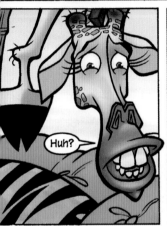

Huh?

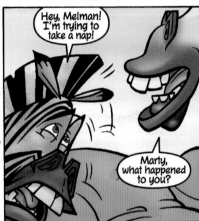

Hey, Melman! I'm trying to take a nap!

Marty, what happened to you?

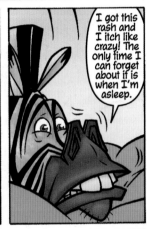

I got this rash and I itch like crazy! The only time I can forget about it is when I'm asleep.

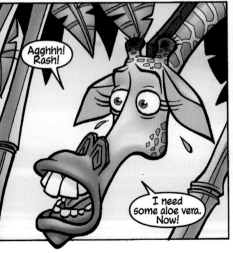

Agghhh! Rash!

I need some aloe vera. Now!

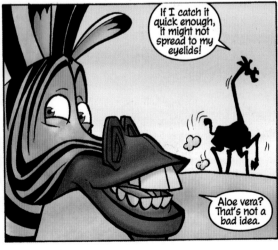

If I catch it quick enough, it might not spread to my eyelids!

Aloe vera? That's not a bad idea.

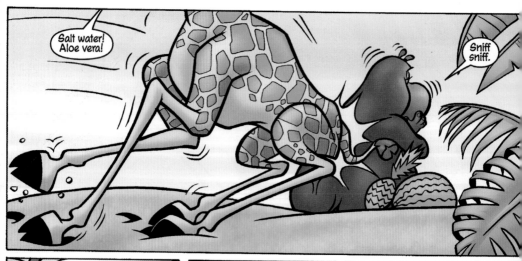

Salt water! Aloe vera!

Sniff sniff.

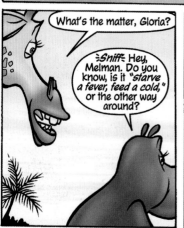

What's the matter, Gloria?

≈Sniff≈ Hey, Melman. Do you know, is it *"starve a fever, feed a cold,"* or the other way around?

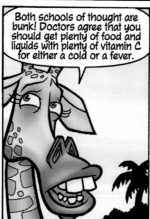

Both schools of thought are bunk! Doctors agree that you should get plenty of food and liquids with plenty of vitamin C for either a cold or a fever.

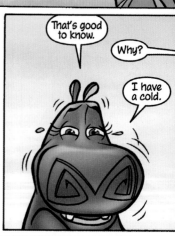

That's good to know.

Why?

I have a cold.

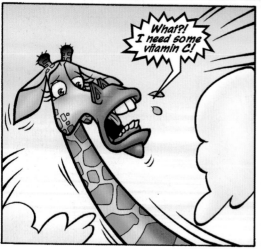

What?! I need some vitamin C!

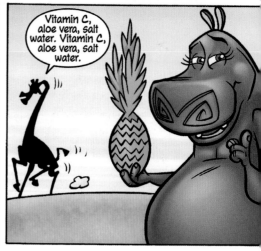

Vitamin C, aloe vera, salt water. Vitamin C, aloe vera, salt water.

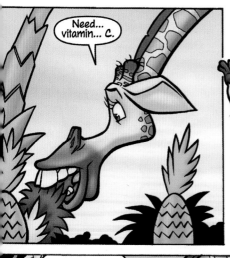

Need... vitamin... C.

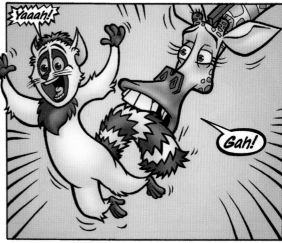

Yaaah!

Gah!

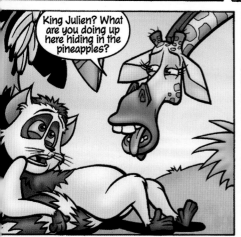

King Julien? What are you doing up here hiding in the pineapples?

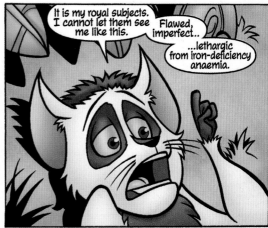

It is my royal subjects. I cannot let them see me like this.

Flawed, imperfect..

...lethargic from iron-deficiency anaemia.

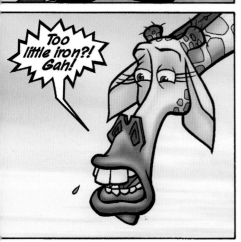

Too little iron?! Gah!

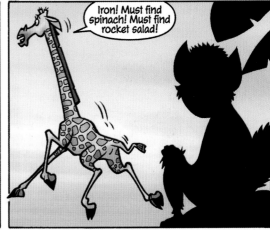

Iron! Must find spinach! Must find rocket salad!

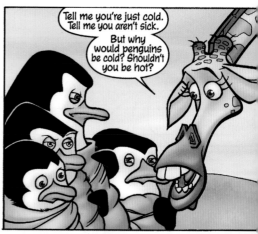

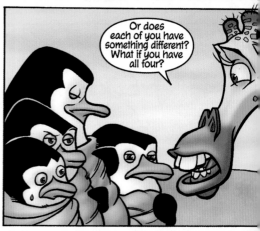

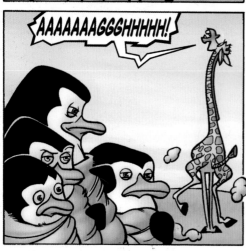

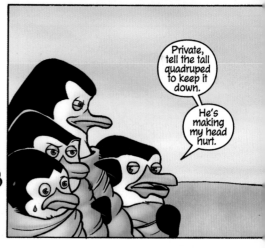

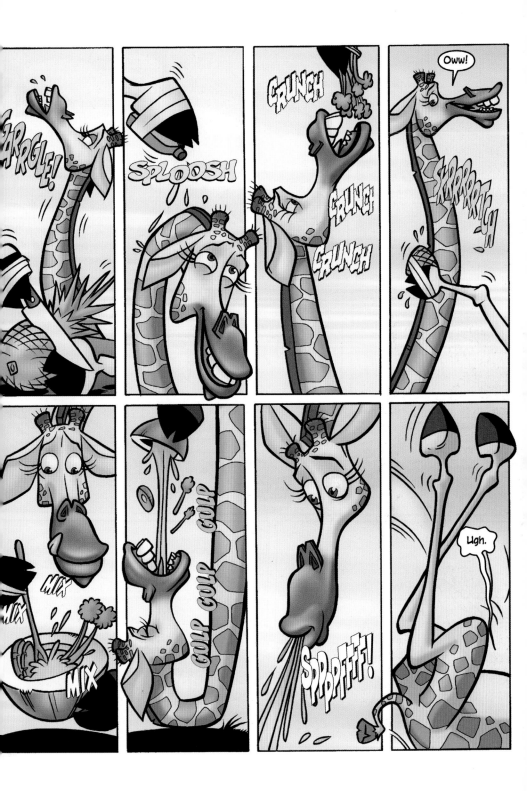

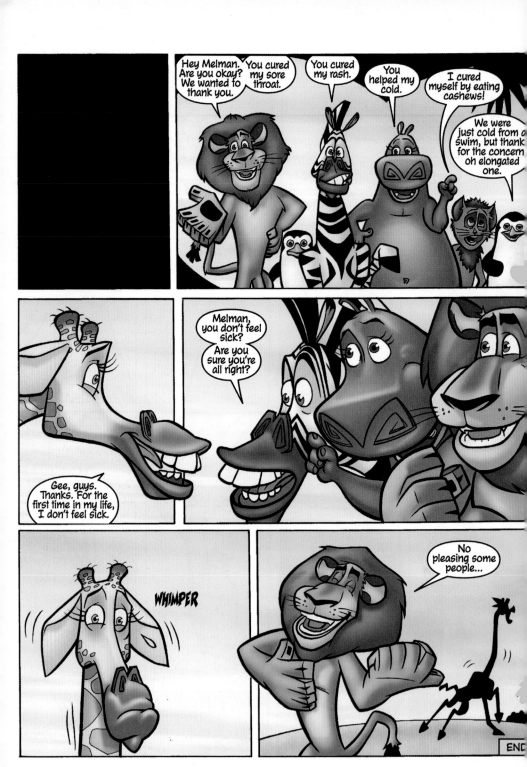

GAME ON

WRITERS DAN ABNETT & ANDY LANNING
ART LAWRENCE ETHERINGTON
LETTERS JIMMY BETANCOURT/COMICRAFT

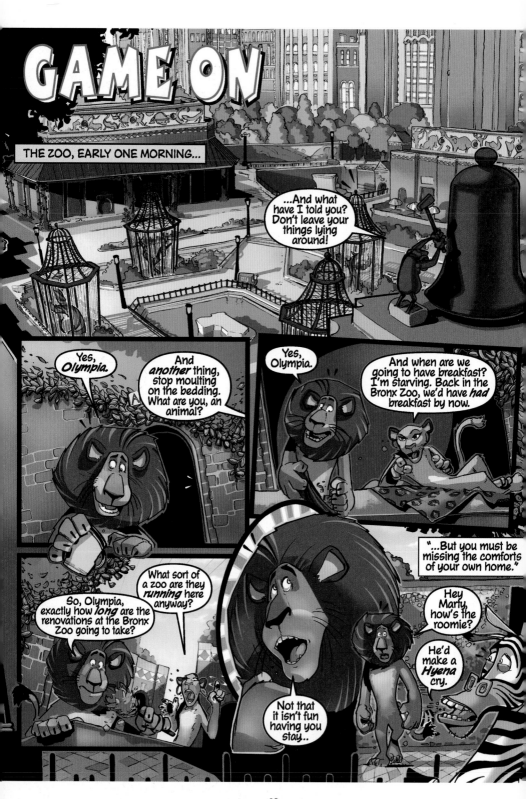

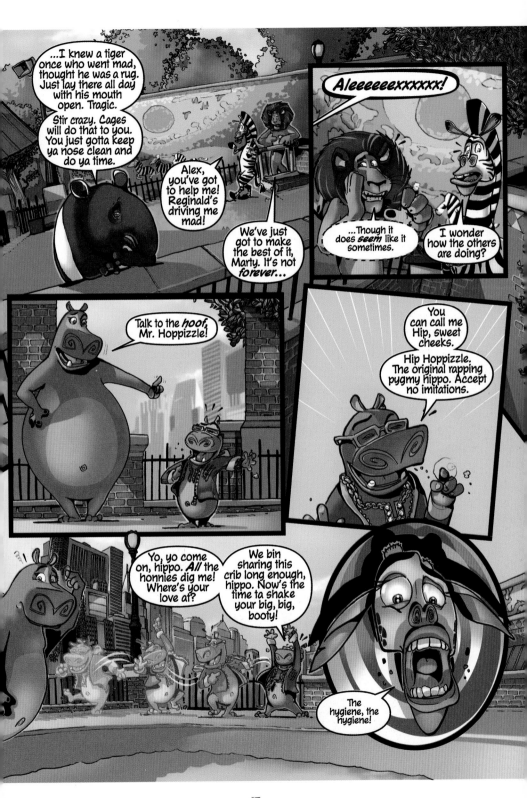

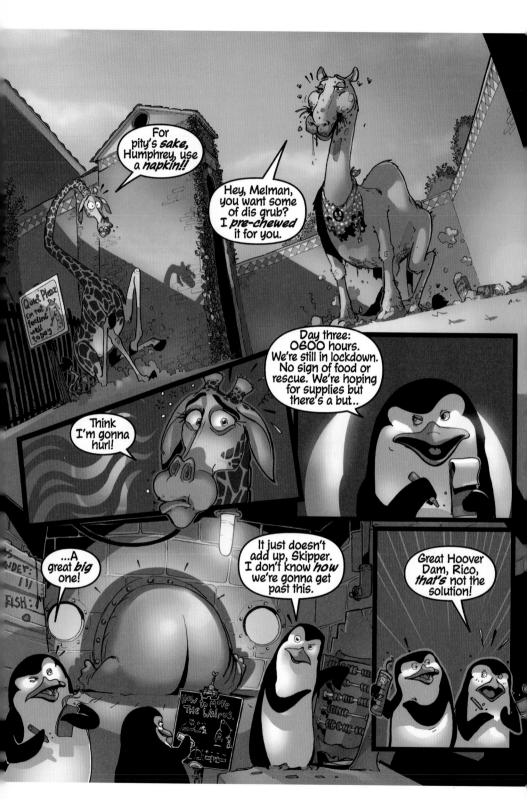

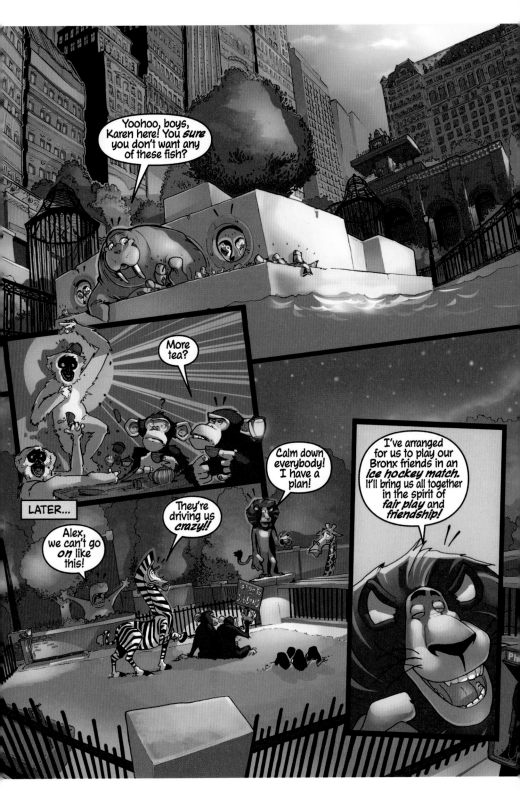

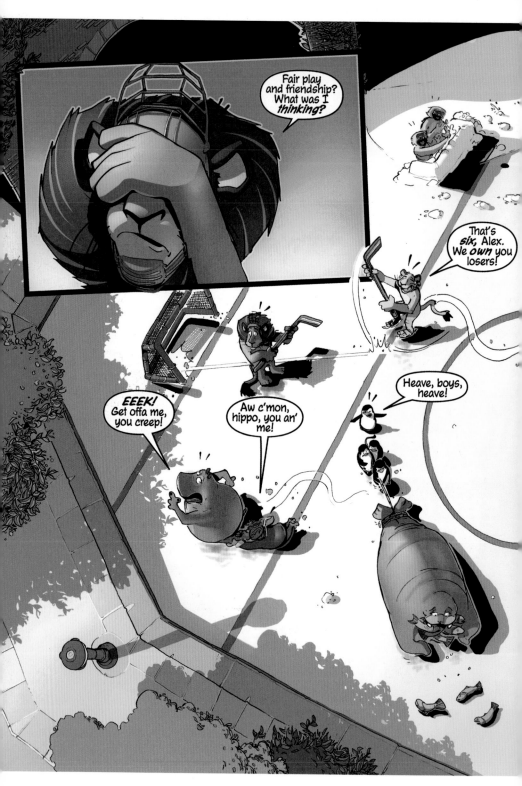

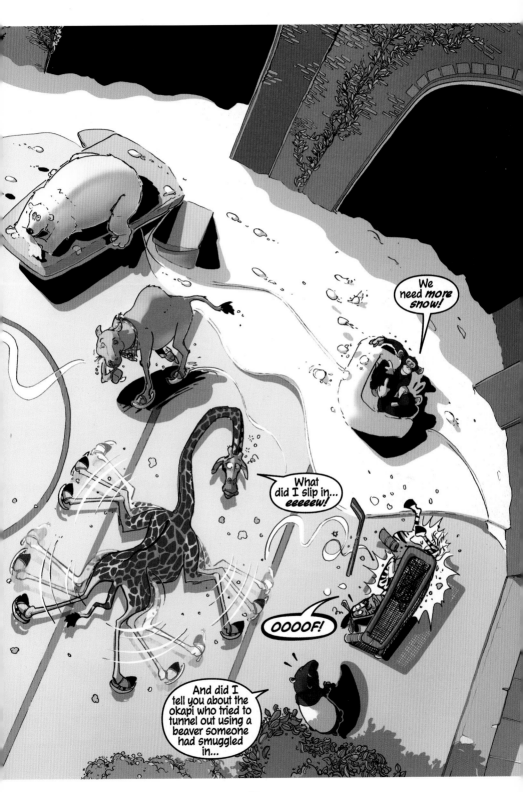

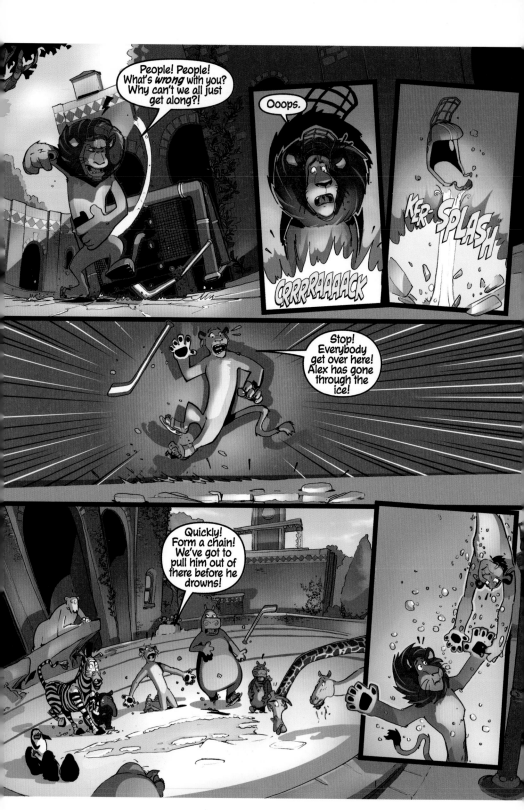

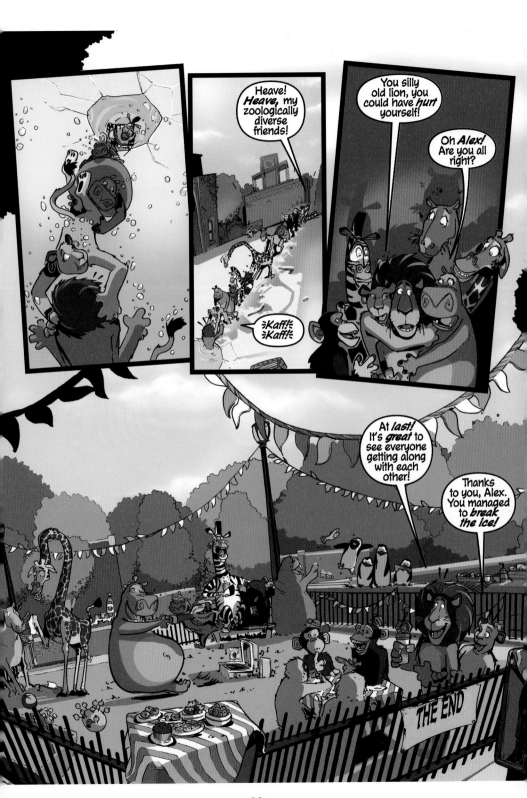

23

COLD FEVER

WRITER **FRED VAN LENTE**
PENCILS **RICARDO LEITE**
INKS **DAN DAVIS**
COLORS **HI-FI DESIGN**
LETTERS **JIMMY BETANCOURT/COMICRAFT**

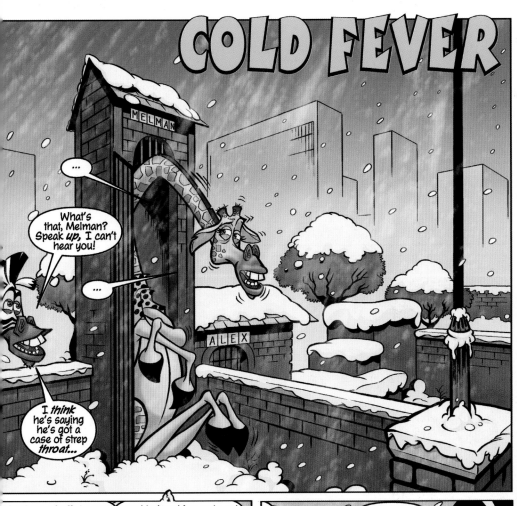

MELMAN

...

What's that, Melman? Speak *up*, I can't hear you!

...

ALEX

I *think* he's saying he's got a case of strep *throat...*

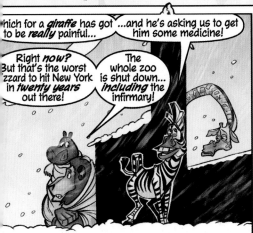

...which for a *giraffe* has got to be *really* painful...

...and he's asking us to get him some medicine!

Right *now?* But that's the worst *lizzard* to hit New York in *twenty years* out there!

The whole zoo is shut down... *including* the infirmary!

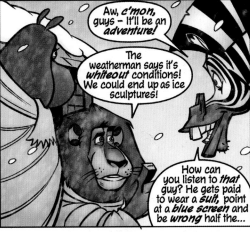

Aw, *c'mon,* guys – It'll be an *adventure!*

The weatherman says it's *whiteout* conditions! We could end up as ice sculptures!

How can you listen to *that* guy? He gets paid to wear a *suit,* point at a *blue screen* and be *wrong* half the...

25

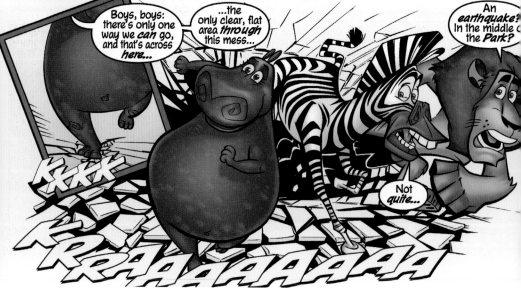

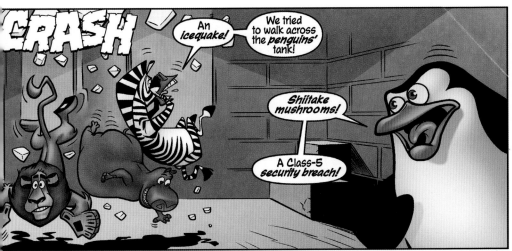

CRASH

An *icequake!*

We tried to walk across the *penguins'* tank!

Shiitake mushrooms!

A *Class-5 security breach!*

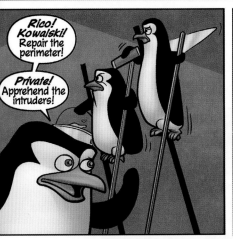

Rico! Kowalski! Repair the perimeter!

Private! Apprehend the intruders!

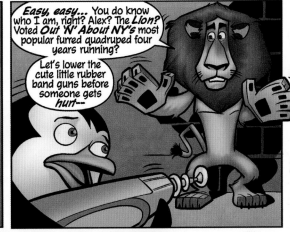

Easy, easy... You do know who I am, right? Alex? The *Lion?* Voted *Out 'N' About NY's* most popular furred quadruped four years running?

Let's lower the cute little rubber band guns before someone gets *hurt--*

SPROING

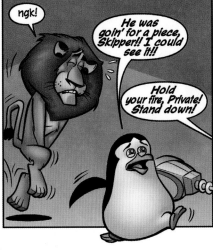

ngk!

He was goin' for a piece, Skipper!! I could see it!!

Hold your fire, Private! Stand down!

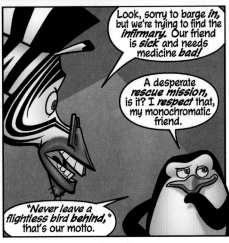

Look, sorry to barge *in*, but we're trying to find the *infirmary.* Our friend is *sick* and needs medicine *bad!*

A desperate *rescue mission*, is it? I *respect* that, my monochromatic friend.

"Never leave a flightless bird behind," that's our motto.

27

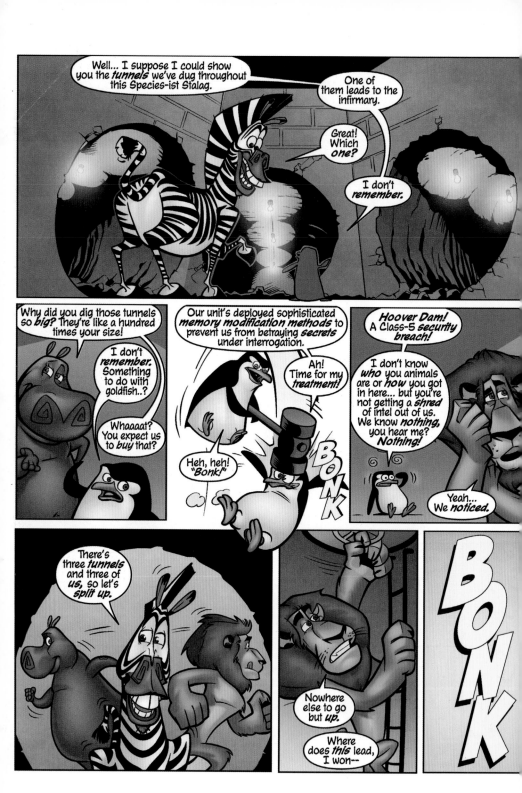

Ah. The *Japanese goldfish* tank.

Owwwww...

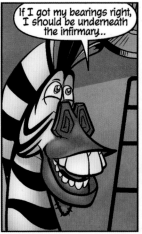

If I got my bearings right, I should be underneath the infirmary..

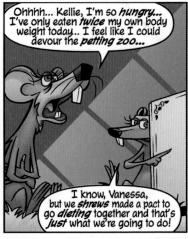

Ohhhh... Kellie, I'm so *hungry*... I've only eaten *twice* my own body weight today.. I feel like I could devour the *petting zoo*...

I know, Vanessa, but we *shrews* made a pact to go *dieting* together and that's *just* what we're going to do!

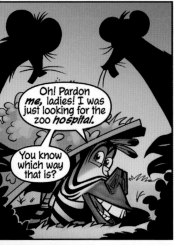

Oh! Pardon *me*, ladies! I was just looking for the zoo *hospital*.

You know which way that is?

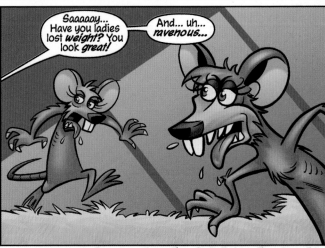

Saaaaay... Have you ladies lost *weight*? You look *great*!

And... uh... *ravenous*...

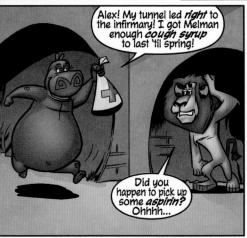

Alex! My tunnel led *right* to the infirmary! I got Melman enough *cough syrup* to last 'til spring!

Did you happen to pick up some *aspirin*? Ohhhh...

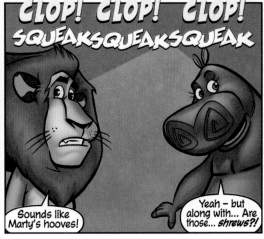

CLOP! CLOP! CLOP! SQUEAKSQUEAKSQUEAK

Sounds like Marty's hooves!

Yeah – but along with... Are those... *shrews*?!

29

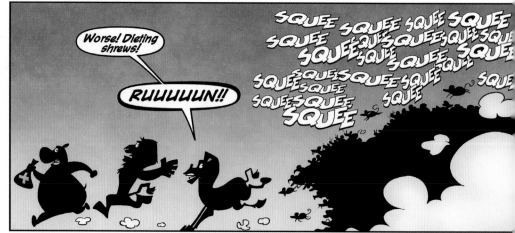

Worse! Dieting shrews!

RUUUUUN!!

SQUEE SQUEE

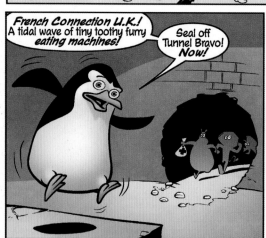

French Connection U.K.! A tidal wave of tiny toothy furry eating machines!

Seal off Tunnel Bravo! Now!

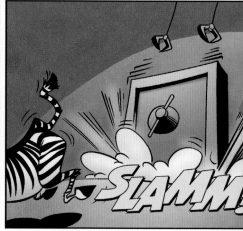

SLAMM

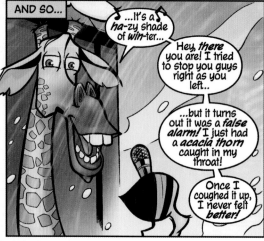

AND SO...

...It's a ha-zy shade of win-ter...

Hey, *there* you are! I tried to stop you guys right as you left..

...but it turns out it was a *false alarm!* I just had a *acacia thorn* caught in my throat!

Once I coughed it up, I never felt *better!*

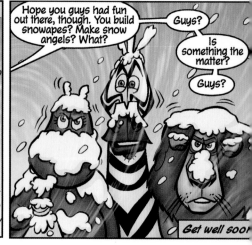

Hope you guys had fun out there, though. You build snowapes? Make snow angels? What?

Guys?

Is something the matter?

Guys?

Get well soon

DREAMWORKS

SHREK

Fiona
Feisty wife of Shrek

Shrek
Loveable ogre

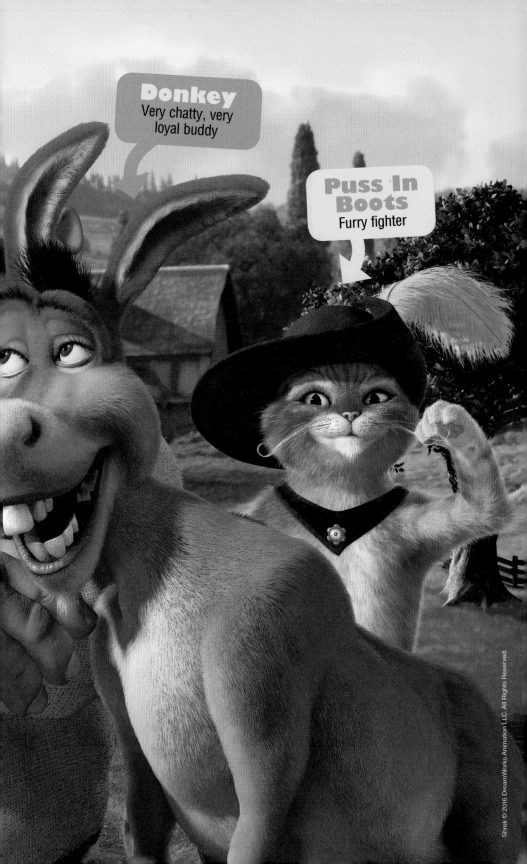

CRIME WAVE

WRITER RIK HOSKIN

PENCILS SL GALLANT

INKS BAMBOS GEORGIOU

COLORS DANIEL KEMP

LETTERS JIMMY BETANCOURT/COMICRAFT

CRIME WAVE

The *enchanted forest,* a haven of *tranquility...*

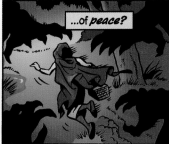

...of *peace?*

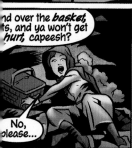

...and over the *basket,* ...s, and ya won't get ...*hurt,* capeesh?

No, ...please...

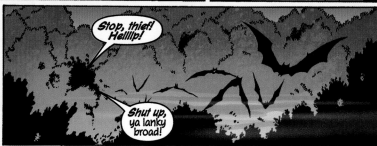

Stop, thief! Helllllp!

Shut up, ya lanky broad!

THE NEXT DAY...

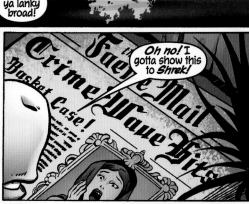

Oh no! I gotta show this to *Shrek!*

Faerye Mail
Crime Wave Hits
Basket Case!

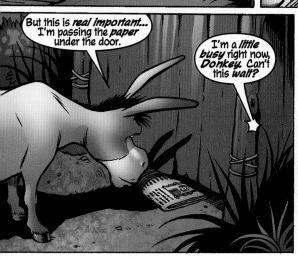

But this is *real important...* I'm passing the *paper* under the door.

I'm a *little busy* right now, *Donkey.* Can't this *wait?*

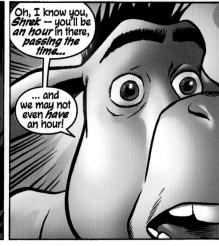

Oh, I know you, *Shrek* -- you'll be *an hour* in there, *passing the time...*

...and we may not even *have* an hour!

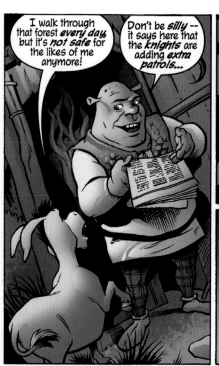

I walk through that forest *every day,* but it's *not safe* for the likes of me anymore!

Don't be *silly* -- it says here that the *knights* are adding *extra patrols...*

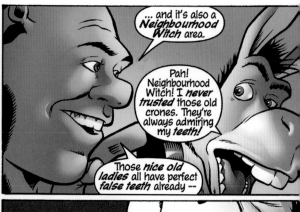

... and it's also a *Neighbourhood Witch* area.

Pah! *Neighbourhood Witch!* I *never trusted* those old crones. They're always admiring my *teeth!*

Those *nice old ladies* all have perfect *false teeth* already --

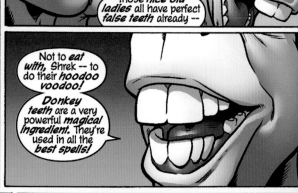

Not to *eat with,* Shrek -- to do their *hoodoo voodoo!*

Donkey teeth are a very powerful *magical ingredient.* They're used in all the *best spells!*

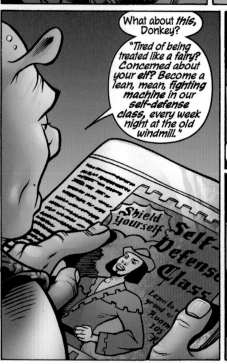

What about *this,* Donkey?

"Tired of being treated like a fairy? Concerned about your elf? Become a lean, mean, fighting machine in our self-defense class, every week night at the old windmill."

Shield Yourself

Self-Defense Class

Learn to grand g. room 105

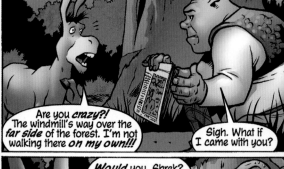

Are you *crazy?!* The windmill's way over the *far side* of the forest. I'm not walking there *on my own!!!*

Sigh. What if I came with you?

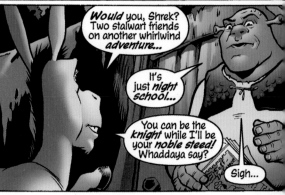

Would you, Shrek? Two stalwart friends on another whirlwind *adventure...*

It's just *night school...*

You can be the *knight* while I'll be your *noble steed!* Whaddaya say?

Sigh...

36

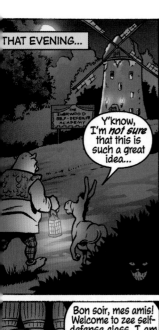

THAT EVENING...

Y'know, I'm *not sure* that this is such a great idea...

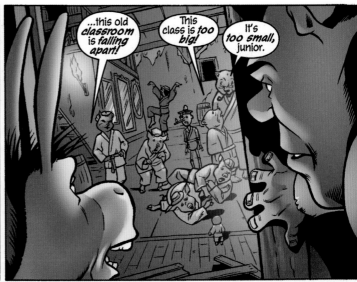

...this old *classroom* is *falling apart!*

This class is *too big!*

It's *too small,* junior.

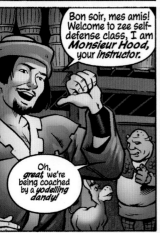

Bon soir, mes amis! Welcome to zee self-defense class, I am *Monsieur Hood,* your *instructor.*

Oh, *great,* we're being coached by a *yodelling dandy!*

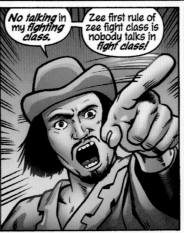

No talking in my *fighting class.*

Zee first rule of zee fight class is nobody talks in *fight class!*

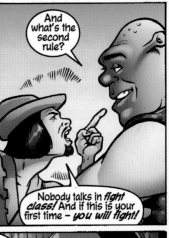

And what's the second rule?

Nobody talks in *fight class!* And if this is your first time – *you will fight!*

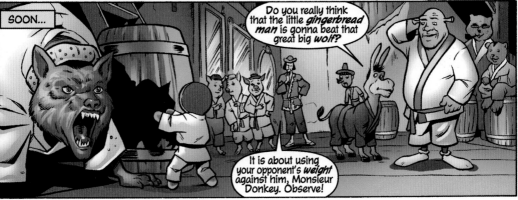

SOON...

Do you really think that the little *gingerbread man* is gonna beat that great big *wolf?*

It is about using your opponent's *weight* against him, Monsieur Donkey. Observe!

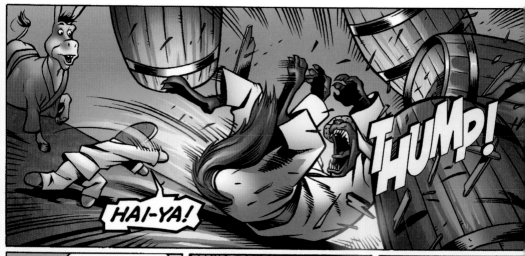

HAI-YA!

THUMP!

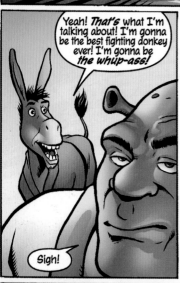

Yeah! *That's* what I'm talking about! I'm gonna be the best fighting donkey ever! I'm gonna be *the whup-ass!*

Sigh!

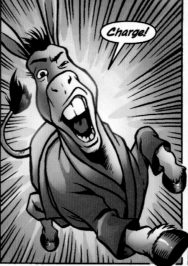

Charge!

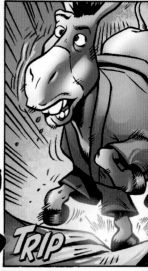

TRIP

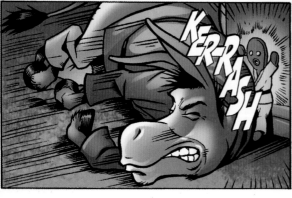

KER-RASH!

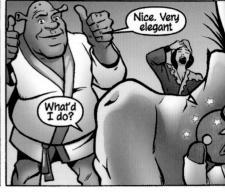

Nice. Very elegant

What'd I do?

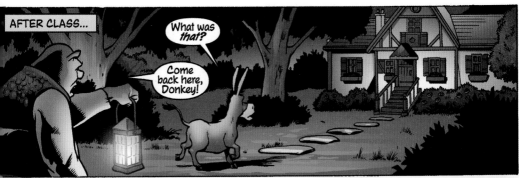

AFTER CLASS...

What was *that*?

Come back here, Donkey!

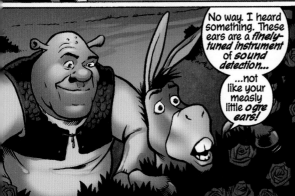

No way. I heard something. These ears are a *finely-tuned instrument* of *sound detection...*

...not like your measly little *ogre ears!*

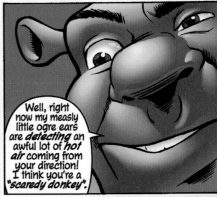

Well, right now my measly little ogre ears are *detecting* an awful lot of *hot air* coming from your direction! I think you're a *"scaredy donkey"*.

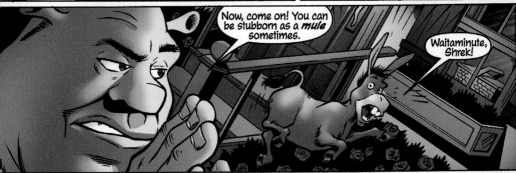

Now, come on! You can be stubborn as a *mule* sometimes.

Waitaminute, Shrek!

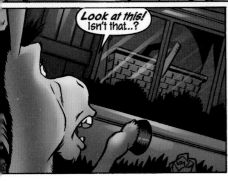

Look at this! Isn't that..?

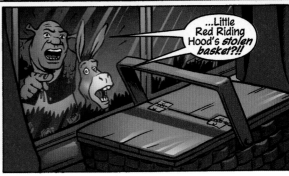

...Little Red Riding Hood's *stolen basket?!!*

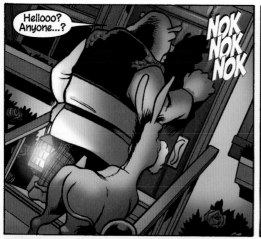

Hellooo? Anyone...?

NOK NOK NOK

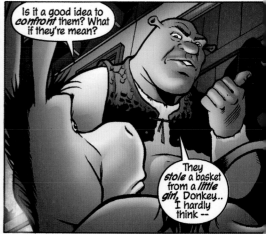

Is it a good idea to *confront* them? What if they're mean?

They *stole* a basket from a *little girl*, Donkey.. I hardly think --

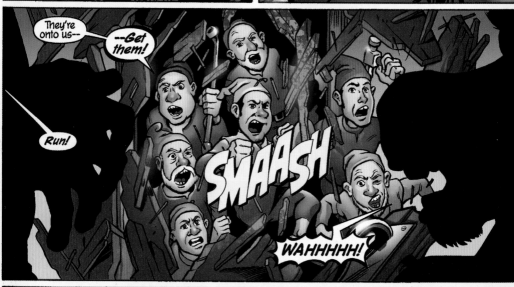

They're onto us--

--*Get them!*

Run!

SMAASH

WAHHHHH!

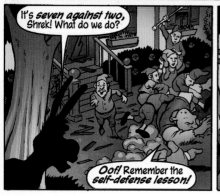

It's *seven against two*, Shrek! What do we do?

Oof! Remember the *self-defense lesson!*

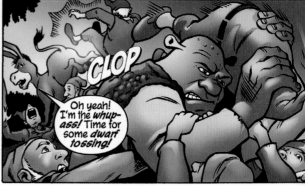

CLOP

Oh yeah! I'm the *whup-ass!* Time for some *dwarf tossing!*

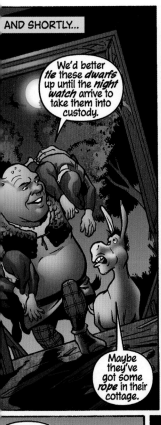

AND SHORTLY...

We'd better *tie* these *dwarfs* up until the *night watch* arrive to take them into custody.

Maybe they've got some *rope* in their cottage.

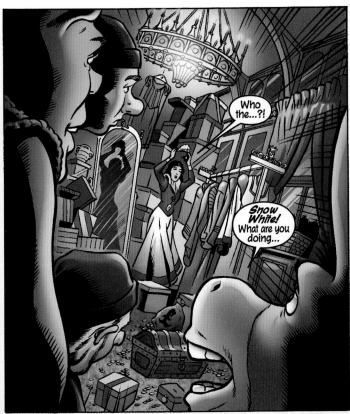

Who the...?!

Snow White! What are you doing...

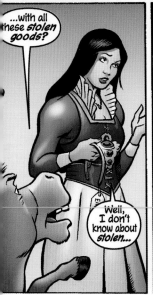

...with all these *stolen goods?*

Well, I don't know about *stolen...*

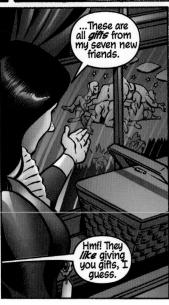

...These are all *gifts* from my seven new friends.

Hmf! They *like* giving you gifts, I guess.

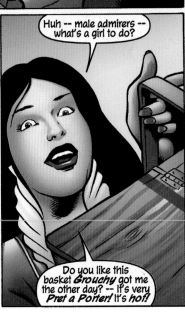

Huh -- male admirers -- what's a girl to do?

Do you like this basket *Grouchy* got me the other day? -- It's very *Pret a Porter!* It's *hot!*

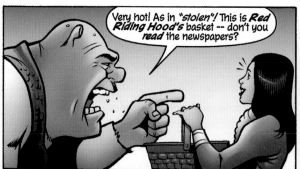

Very hot! As in *"stolen"!* This is *Red Riding Hood's* basket -- don't you *read* the newspapers?

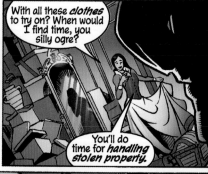

With all these *clothes* to try on? When would I find time, you silly ogre?

You'll do time for *handling stolen property.*

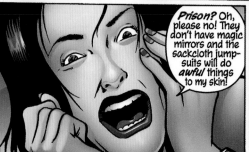

Prison? Oh, please no! They don't have magic mirrors and the sackcloth jumpsuits will do *awful* things to my skin!

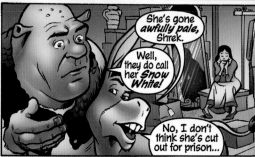

She's gone *awfully pale,* Shrek.

Well, they do call her *Snow White!*

No, I don't think she's cut out for prison...

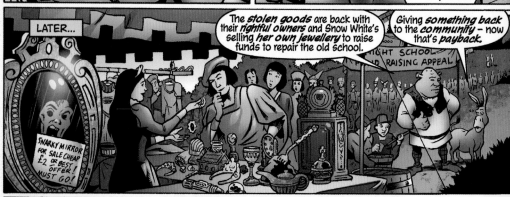

LATER...

The *stolen goods* are back with their *rightful owners* and Snow White's selling *her own jewellery* to raise funds to repair the old school.

Giving *something back* to the *community* – now that's *payback.*

SNARKY MIRROR FOR SALE CHEAP £2 OR BEST OFFER! MUST GO!

I never did trust *diminutive folks,* Shrek.

You are *quite short* yourself, you know?

But I've got *four legs,* Shrek -- that's like a whole *different* category.

Hah-hah-hah!

Come along, *shorty,* let's go buy something for Fiona.

K.O.'d!

42

THE GREAT TART ROBBERY

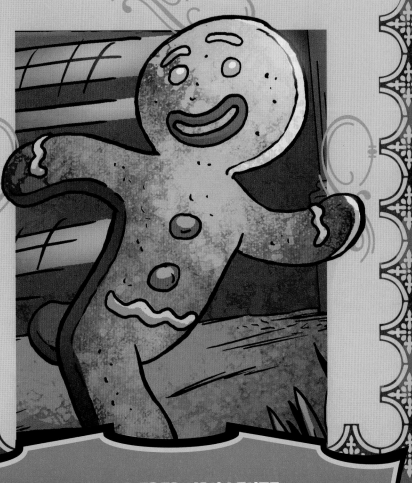

WRITER **FRED VAN LENTE**
ART **BRIAN WILLIAMSON**
COLORS **DAN KEMP**
LETTERS **JIMMY BETANCOURT/COMICRAFT**

THE GREAT TART ROBBERY

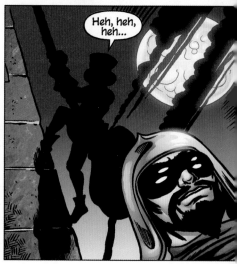

Heh, heh, heh...

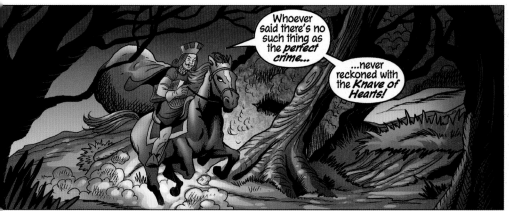

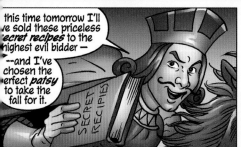

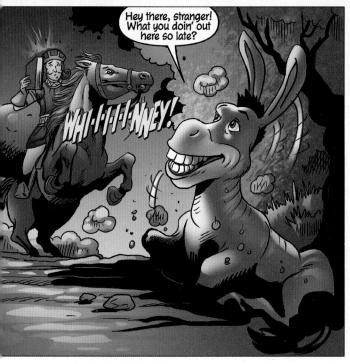

45

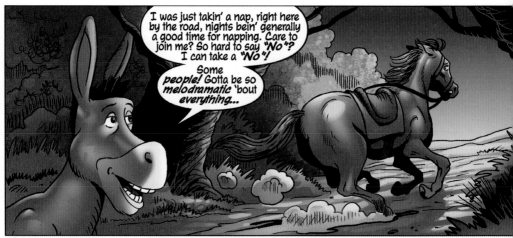

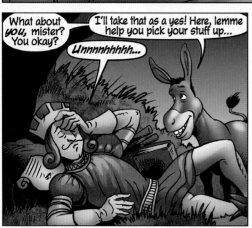

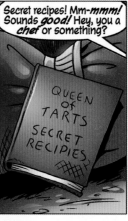

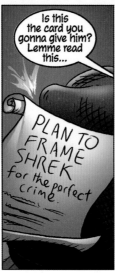

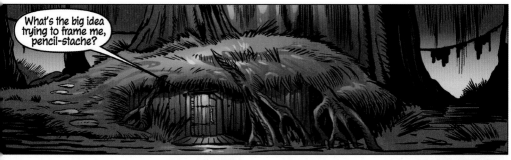

What's the big idea trying to frame me, pencil-stache?

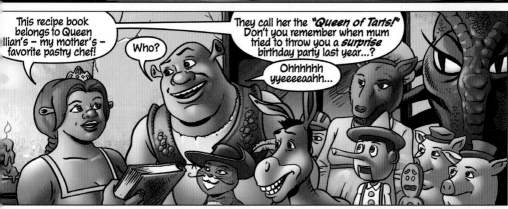

This recipe book belongs to Queen Illian's – my mother's – favorite pastry chef!

Who?

They call her the *"Queen of Tarts!"* Don't you remember when mum tried to throw you a *surprise* birthday party last year...?

Ohhhhhh yyeeeeaahh...

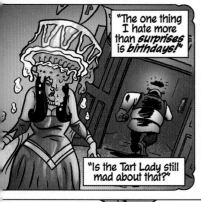

"The one thing I hate more than *surprises* is *birthdays!*"

"Is the Tart Lady still mad about that?"

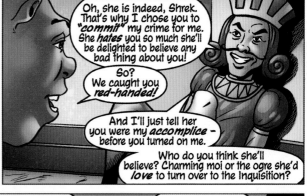

Oh, she is indeed, Shrek. That's why I chose you to *"commit"* my crime for me. She *hates* you so much she'll be delighted to believe any bad thing about you!

So? We caught you *red-handed!*

And I'll just tell her you were my *accomplice* – before you turned on me.

Who do you think she'll believe? Charming moi or the ogre she'd *love* to turn over to the Inquisition?

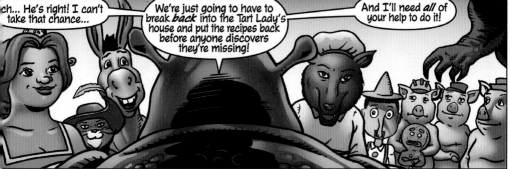

ch... He's right! I can't take that chance...

We're just going to have to break *back* into the Tart Lady's house and put the recipes back before anyone discovers they're missing!

And I'll need *all* of your help to do it!

47

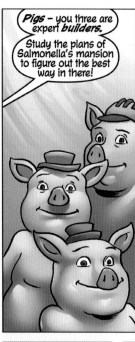

Pigs – you three are expert *builders*.

Study the plans of Salmonella's mansion to figure out the best way in there!

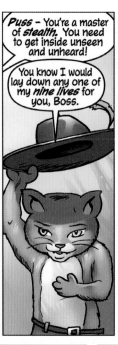

Puss – You're a master of *stealth*. You need to get inside unseen and unheard!

You know I would lay down any one of my *nine lives* for you, Boss.

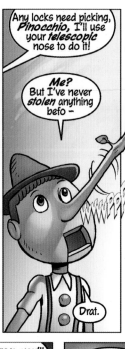

Any locks need picking, *Pinocchio*, I'll use your *telescopic* nose to do it!

Me? But I've never *stolen* anything befo –

Drat.

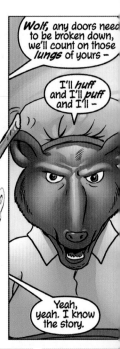

Wolf, any doors need to be broken down, we'll count on those *lungs* of yours –

I'll *huff* and I'll *puff* and I'll –

WWWPP

Yeah, yeah. I know the story.

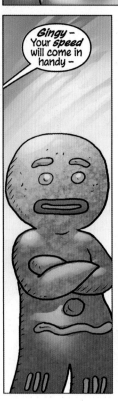

Gingy – Your *speed* will come in handy –

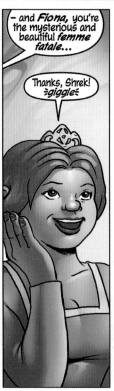

– and **Fiona**, you're the mysterious and beautiful *femme fatale*...

Thanks, Shrek! ≳giggle≲

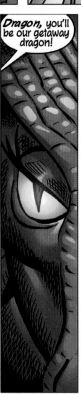

Dragon, you'll be our getaway dragon!

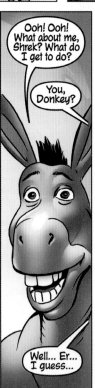

Ooh! Ooh! What about me, Shrek? What do I get to do?

You, Donkey?

Well... Er... I guess...

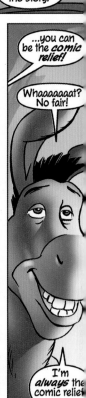

...you can be the *comic relief!*

Whaaaaaat? No fair!

I'm *always* the comic relief!

48

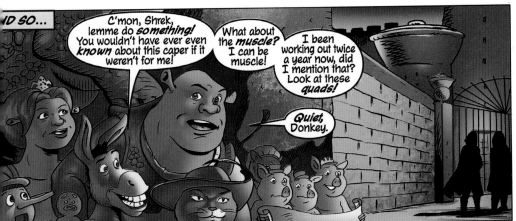

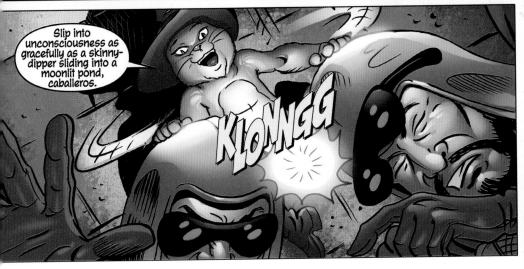

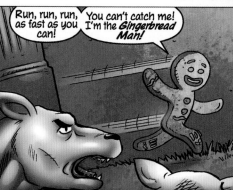

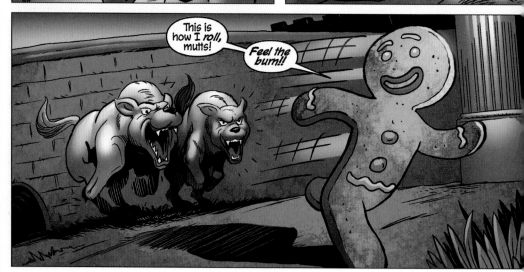

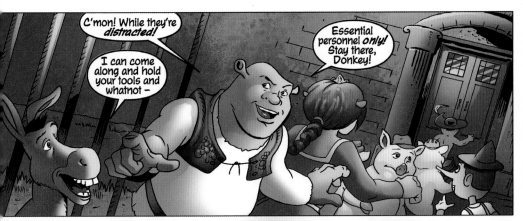

C'mon! While they're *distracted!*

I can come along and hold your tools and whatnot –

Essential personnel *only!* Stay there, Donkey!

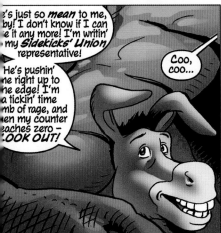

...e's just so *mean* to me, ...by! I don't know if I can ...e it any more! I'm writin' ...my *Sidekicks' Union* representative!

He's pushin' ...ne right up to ...he edge! I'm ...a tickin' time ...mb of rage, and ...en my counter ...eaches zero – LOOK OUT!

Coo, coo...

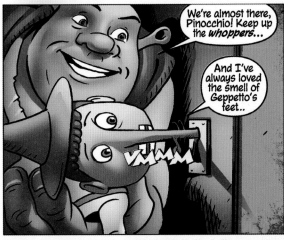

We're almost there, Pinocchio! Keep up the *whoppers...*

And I've always loved the smell of Geppetto's feet..

VMMM

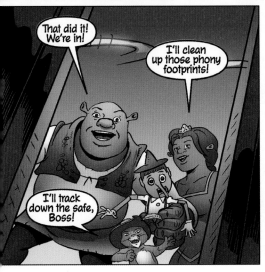

That did it! We're in!

I'll clean up those phony footprints!

I'll track down the safe, Boss!

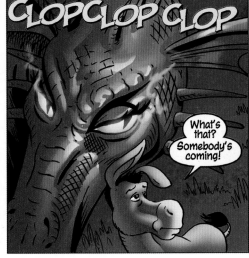

CLOP CLOP CLOP

What's that? Somebody's coming!

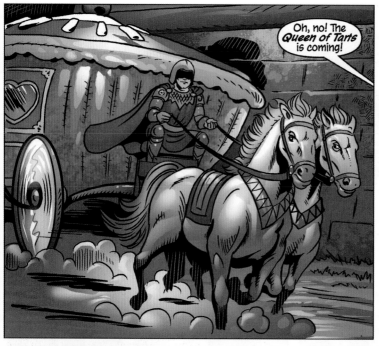

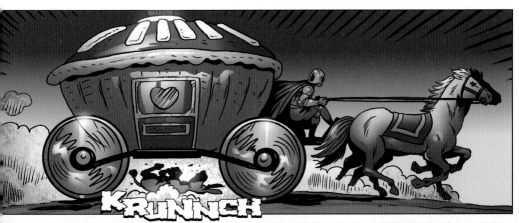

KRUNNCH

The place is **spotless** – the recipes are safe and sound in their safe!

This is the perfect **cover-up** of the perfect crime!

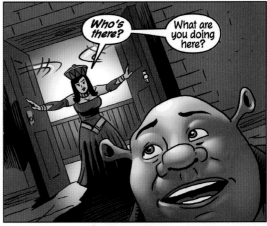

Who's there?

What are you doing here?

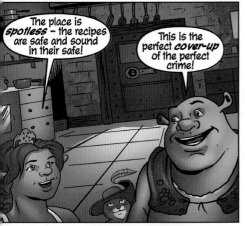

Never mind! Only one thing matters right now –

– and that's the health of your poor, **wounded** animal!

?!?

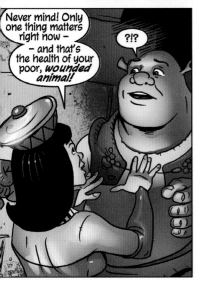

Turns out Tart Lady was happy to forget the whole incident as long as we didn't report Donkey's accident!

Apparently she runs a chain of wildlife sanctuaries on top of all the cooking... and if it got out she'd **mown down** a helpless animal, well, I'm sure people would find the taste of her pies somewhat sour!

I always knew you were an important member of the team, Donkey! But you're my **best friend** – I didn't want you to get hurt!

Yeah...? How's... how's that workin' **out?** Kof!

The Ever-Loving End!

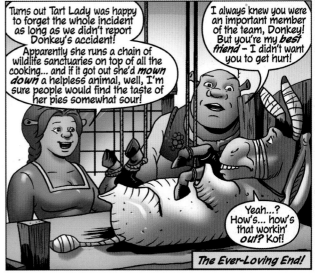

BLIND LUCK

WRITER **ANDREW DABB**
ART **MAURICIO MELO/MAGIC EYE STUDIOS**
COLORS **KAT NICHOLSON**
LETTERS **JIMMY BETANCOURT/COMICRAFT**

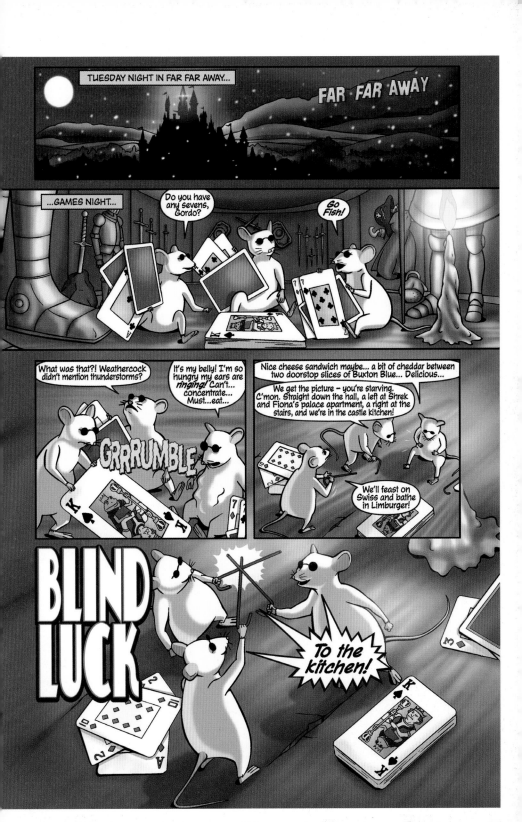

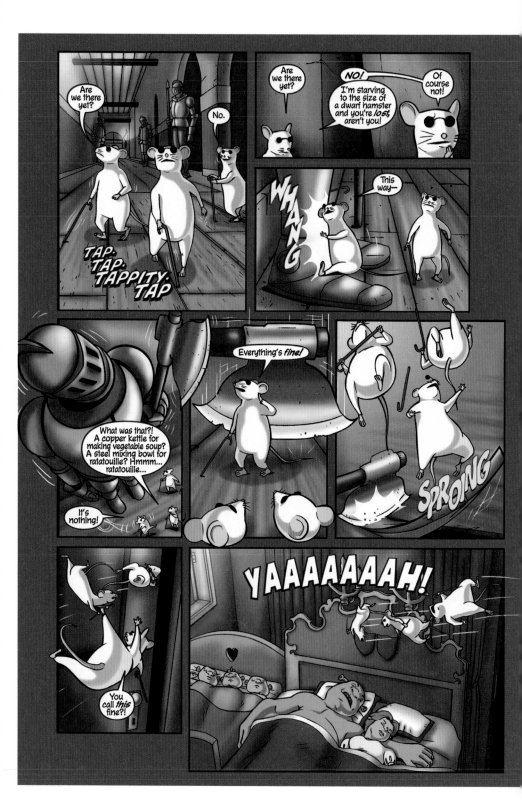

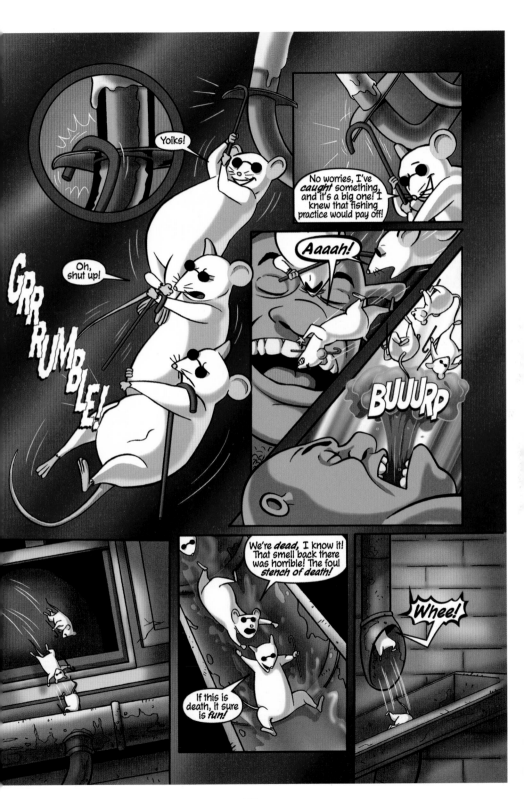

TINK TONK TIK

Still can't get comfy..

PLIP PLINK

Stupid pea...

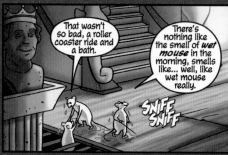

That wasn't so bad, a roller coaster ride and a bath.

There's nothing like the smell of *wet mouse* in the morning, smells like... well, like wet mouse really.

SNIFF SNIFF

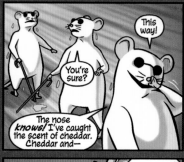

You're sure?

This way!

The nose *knows!* I've caught the scent of cheddar. Cheddar and—

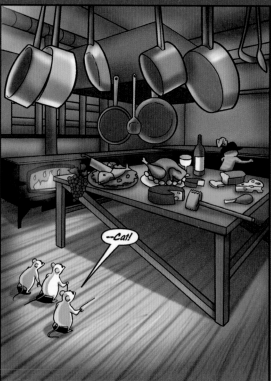

--Cat!

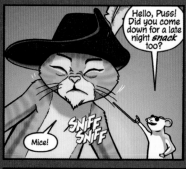

Hello, Puss! Did you come down for a late night *snack* too?

Mice!

SNIFF SNIFF

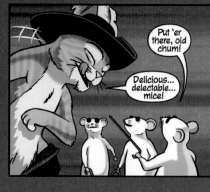

Put 'er there, old chum!

Delicious... delectable... mice...

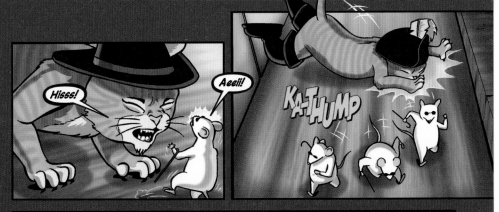

Hisss!

Aeeii!

KA-THUMP

He tried to *eat me!*

Puss would never eat us! We're *friends!*

Then he must not be Puss. He's *sleepwalking!*

That explains it – his instincts have overcome his usually impeccable manners!

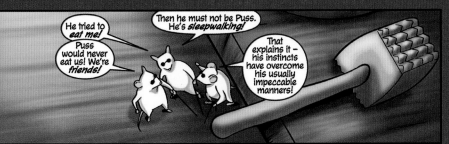

Rats! As it were. No cheese for us.

Unless...if we can lull Puss back to *sleep...* What about a lullaby?

He's already asleep!

We just need to relax him. Wait – I have a cunning plan!

≶ahem≶

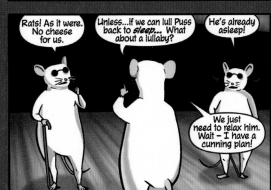

Ah-one, ah-two, ah-one-two-three-FOUR!

♪Go to sleeeep, little kiiiiitty..♪

Time to reeeest your weaaaary head...♪

♪From your eeeeears to your whiiiiskers...

You must be feeeeling haaaaalf-dead...

Half-dead? That's not very kind.

Better than being all-dead if he catches us. Besides, I'm making it up as I go along!

♪Your boots are heeeeavy, and you're tiiiiired...♪

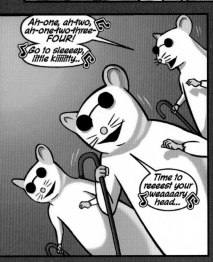

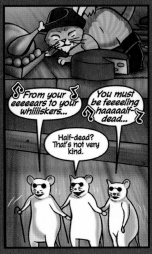

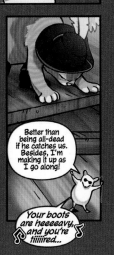

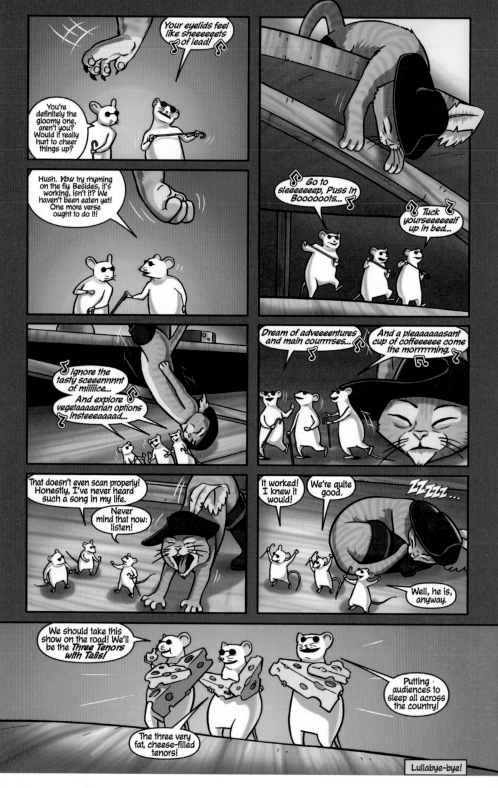

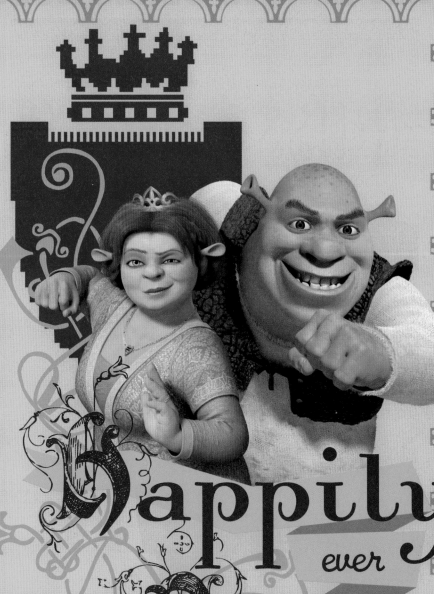

Happily *ever* After

TITAN COMICS COMIC BOOKS

AVAILABLE MONTHLY NOW!
ALSO AVAILABLE DIGITALLY.
WWW.TITAN-COMICS.COM

TITAN COMICS DIGESTS

Dreamworks Classics
– 'Hide & Seek'

Dreamworks Classics
– 'Consequences'

Dreamworks Classics
– 'Game On'

Home –
Hide & Seek & Oh

Home –
Another Home

Kung Fu Panda –
Daze of Thunder

Kung Fu Panda –
Sleep-Fighting

Penguins of
Madagascar – When in
Rome...

Penguins of
Madagascar –
Operation: Heist

DreamWorks Dragons:
Riders of Berk –
Dragon Down

DreamWorks Dragons:
Riders of Berk –
Dangers of the Deep

DreamWorks Dragons:
Riders of Berk –
The Ice Castle

DreamWorks Dragons:
Riders of Berk –
The Stowaway

DreamWorks Dragons:
Riders of Berk – The
Legend of Ragnarok

DreamWorks Dragons:
Riders of Berk –
Underworld

DreamWorks Dragons:
Defenders of Berk -
The Endless Night

WWW.TITAN-COMICS.COM
ALSO AVAILABLE DIGITALLY